E. Shong

MY DEAR MR. HOPPER

My dear Mr. Hopper —

Edited and with an Introduction by
Elizabeth Thompson Colleary

Yale University Press
New Haven and London

in association with
Whitney Museum of American Art
New York

www.yalebooks.com/art

Copyedited by Miranda Ottewell
Proofread by John Mordecai
Designed by Yve Ludwig
Set in Centaur and Benton Sans by Yve Ludwig
Printed in China by Regent Publishing Services Limited

Library of Congress Cataloging-in-Publication Data
Hilsdale, Alta, 1884–1948.
My Dear Mr. Hopper / Edited and with an introduction by
Elizabeth Thompson Colleary.
pages cm
Includes bibliographical references.
ISBN 978-0-300-18148-7 (hardback)
1. Hopper, Edward, 1882–1967— Correspondence. 2. Hilsdale,
Alta, 1884–1948— Correspondence. 3. Painters— United States—
Correspondence. I. Colleary, Elizabeth Thompson, editor. II. Title.
ND237.H75A3 2013
759.13— dc23

 2012041735

A catalogue record for this book is available from the British Library.

The paper in this book meets the requirements of
ANSI/NISO Z39.48-1992 (Permanence of Paper).

10 9 8 7 6 5 4 3 2 1

Jacket illustrations: *(front)* letter and envelope, postmarked November
29, 1906; *(back)* Edward Hopper in Paris, 1907. The Arthayer R. Sanborn
Hopper Collection Trust—2005

Page viii: letter, postmarked May 19, 1907

Photographic credits: © Heirs of Josephine N. Hopper, licensed by
the Whitney Museum of American Art, N.Y. Digital image © Whitney
Museum of American Art (figs. 1, 2, 4); Photograph by Sheldan C. Collins
(figs. 6, 8)

Facsimiles and transcriptions of letters reproduced with permission of
the Arthayer R. Sanborn Hopper Collection Trust—2005.

Note: Sauk Centre, Minnesota, is spelled Sauk Center in the
transcriptions, as per the spelling in the postmarks and the letters.

For Steven P. Hollman

I am grateful to the late Reverend Arthayer Sanborn and his son
Philip for sharing their Hopper holdings with me. At the Whitney
Museum of American Art I thank Beth Huseman, Director of
Publications; Anita Duquette, Manager, Rights and Reproductions;
and the Frances Mulhall Achilles Library staff: Carol Rusk, Irma
and Benjamin Weiss Librarian, and Kristen Leipert, Assistant
Archivist, for their invaluable advice and assistance. I am also
indebted to Avis Berman and Stephen Borkowski, generous
colleagues who have the art spirit.

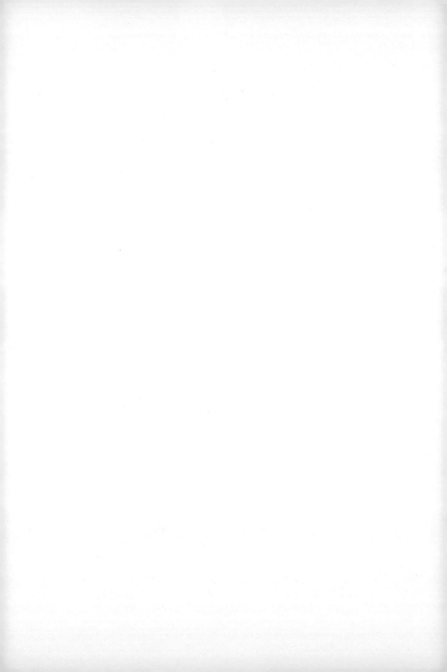

CONTENTS

My dear Mr. Hopper—
 Yes, I
should like very
much to go out
to dinner tonight.
I shall expect
you at about
seven—
 Sincerely,
 Alta Hilsdale

INTRODUCTION

Elizabeth Thompson Colleary

Long recognized as the preeminent twentieth-century American realist painter, Edward Hopper (1882–1967) is best known for his portrayal of the modern condition, with isolated figures and stark urban and rural views. He was notoriously shy, introverted, and reclusive; by all accounts, he rarely spoke about his life and work, revealing few personal details and little information about his compelling and often mysterious art. With the exception of a few brief published statements about his goals as an artist,[1] what little we know about Hopper's temperament, thoughts, and feelings is largely based on the observations and recollections of others. His romantic interests were few and his social interactions were largely limited to people he encountered in the course of his artistic pursuits, including Guy Pène du Bois, who described Hopper in 1931 as a "quiet, retiring, restrained man who has been working for a number of years in New York and Paris, almost as a hermit."[2] Until now there have been only two previously documented romantic liaisons prior to the artist's marriage to Josephine Nivison (1883–1968) in 1924 when he was forty-two and she was forty-one. One was brief, with an English girl, Enid Saies, in Paris during 1906–7; the second, with an older French woman, Jeanne Cheruy, in New York, lasted from around 1915 to 1923.

There was, however, another woman who was of romantic interest to Hopper: Alta Hilsdale (1884–1948).

Hopper stored fifty-eight previously unknown letters and one note from Hilsdale for decades in the attic of his boyhood home in Nyack, New York. After the death of the artist's widow in 1968, a close friend of the couple, the Reverend Arthayer Sanborn, discovered the letters when he acquired the contents of the attic of the Nyack home as it was being emptied. Carefully stored by Hopper in a white box held together by rubber bands, the letters were arranged by date and kept inside their original envelopes.[3] During a 2006 interview, Sanborn described "many letters that [Hopper] kept . . . boxes stuffed with them" and said that one in particular, a 1914 letter from Hilsdale telling him that she was to be married, had left Hopper "stricken." Sanborn also noted that unlike Hopper's relationships with Saies and Cheruy,[4] he "had kept his romance with Alta a secret," never acknowledging Hilsdale's presence in his life to anyone during the ten years while he was pursuing her or in the years thereafter.[5]

The extant letters from Hilsdale begin in June of 1904, when Hopper was twenty-one years old and she was twenty; she first wrote to him in Nyack from her home in Minnesota after returning from New York. Her references to finding space for an art studio and not having time to sketch could indicate that the two met at the New York School of Art, where Hopper had studied and began to teach later that year. Their correspondence continued

intermittently through October 1914 after Hilsdale wrote to say that she was to be married to a "Mr. Bleecker" and would reside in Brooklyn. The letters were sent from Minnesota and the places she stayed during lengthy sojourns to Paris and New York; they reached Hopper at various home and studio addresses in Paris and New York. Hopper's letters to Hilsdale have not surfaced, but her responses to his overtures make it possible to reconstruct some details as to the frequency of his requests to see her, where they spent time, and the overall tenor of their relationship during the artist's critical formative years in Paris—a time when the foundation was laid for his mature work. Although we will never know why Hopper kept his relationship with Hilsdale a secret, the letters dispel the myth of his reclusive life during his Paris years[6] and allow us to reconsider some of the art Hopper produced from 1904 to 1914 as well as in subsequent years.

Little is known about Hilsdale, but an 1895 Minnesota census lists an eleven-year-old "Alla" Hilsdale, most likely a reference to Alta, who was born in 1884.[7] As reported in the obituary of Alta's father, William O. P. Hilsdale, he was born in Norway to a farmer, and became a wealthy merchant banker after immigrating to the United States. Alta's mother, Gyda Norderhaus, was described as "a gifted and talented teacher and member of one of the oldest Minnesota families."[8] According to her letters, it was much to Hilsdale's consternation that her father had decided the

family should live on a farm; she often complained of feeling isolated and trapped there, with endless chores to do at the mercy of extreme weather conditions.[9] The Hilsdales likely sent their daughter to study and tour in New York and Paris to groom her to be a cultured and suitable wife. She settled in Paris on three occasions during the course of her ten years of correspondence with Hopper, and while living there she described taking private lessons in French and other subjects, sightseeing with a governess, and attending art exhibitions and other cultural activities with many friends, some of whom, like Hopper, seemingly vied for her time and perhaps her affection.

When Hopper received his first extant letter from Hilsdale in 1904, he had been studying at the New York School of Art for six years and had begun earning income from commercial work, which he pursued until his etchings and watercolors began to sell well enough for him to give it up altogether in 1924. During the decade when his relationship with Hilsdale unfolded, on three occasions, Hopper, like other serious artists of his generation, traveled to Paris to study the work of the old masters as well as the innovations of contemporary painters. In 1908 Hopper began to exhibit his paintings, initially pictures from Paris and then American subjects, in group exhibitions with his contemporaries from the New York School of Art, George Bellows, Robert Henri, John Sloan, and Guy Pène du Bois, among them.[10] While their work found buyers, his did not; he sold only one painting, *Sailing* (1911), from the

famed 1913 Armory show in New York. In his letters to Hilsdale, Hopper must have complained about toiling away at commercial work for needed income, since she wrote in October 1912: "Do you get much painting done, or does your work leave you too fagged? I hope not."[11] At the time, critics ignored Hopper's paintings or gave them only a cursory nod, with one noting in 1912 that Hopper had "an eye for movement and mass."[12] His friend Pène du Bois once noted with brutal honesty that Hopper's work had "considerable austerity and baldness," and that the artist "carries elimination to unfortunate extremes."[13] This starkness, later embraced as a hallmark of Hopper's mature style, could explain the lack of interest in his early oil paintings. His critical and financial fortunes turned dramatically, however, when a 1924 exhibition of watercolors at the Frank K. M. Rehn Gallery in New York sold out.[14]

The bulk of the letters were written while Hopper and Hilsdale were in Paris, for ten months in 1906–7, four months in 1909, and six weeks in 1910, when Hopper was regularly asking Hilsdale to accompany him to dinner, the theater, an art exhibit, or on a day trip outside the city. Despite the endearing salutation, "My Dear Mr. Hopper," used in almost all of the letters, her responses to his invitations were often brief and dismissive. Hilsdale's tone makes it clear that she had the upper hand; she frequently refused his overtures outright or suggested alternate plans—often stating that she was too busy to see him or that she had other social engagements. When viewed in their entirety,

the fifty-eight letters and one undated note from Hilsdale can be seen as documenting Hopper's frustration in trying to establish a romantic relationship with her. On several occasions it is clear from her replies that he had expressed his dismay that she had not responded to his letters and invitations in a timely and courteous fashion. This pattern was set from the onset of their correspondence; in her second extant letter, of July 22, 1904, she announced that she was not one to write often and called him "a most astonishingly impatient person."[15] In the decade that followed she was consistently apologetic for not responding to him, and freely acknowledged that she had been negligent, lazy, or "beastly," as she did on January 31, 1907. In one of her responses from late 1908, she described "a very alarming dream . . . you tried to throw me down a cliff or something. . . . I decided you must be hating me very hard to cause such a dream and wondered if it is because I have never answered your note asking me when I was going to be in New York again."[16] The most profoundly telling indication that Hopper perhaps wanted more from the relationship than Hilsdale did can be found in a note that was in the box with the other letters. Written on a loose piece of paper, not tucked into an envelope as all the other letters had been, it bears no date, salutation, or signature but is clearly composed in Hilsdale's hand, albeit quite sloppily, on the top half of a folded page of paper identical to that of many of her other letters. Her unusually careless penmanship—some words are barely legible, and others crossed out—reinforces

the distressed emotional state conveyed by Hilsdale's words: "You are the type of a man who does not believe a girl can be platonic indefinitely. It seems that you are in a class who regards every girl as one with designs to besiege your affections."[17] Whatever overtures precipitated this somewhat heated response, it is possible that, as he had in his relationship with Saies a few years earlier,[18] Hopper may have waited until Hilsdale was committed to marriage before expressing the depths of his feelings, and that Hilsdale was taken aback by this revelation. This pattern of reticence in his personal life, as he apparently sought romantic fulfillment and intimacy, provides some insight into the experiences and emotions that inspired his art.

Although we will never know precisely how Hopper's relationship with Hilsdale influenced his work during and after the time he spent with her in Paris, the emotions revealed in her letters likely had some bearing on the places he chose to depict, as well as on figure types he would use for decades to come. A group of Parisian oils — *Le Parc de Saint-Cloud* (fig. 1), *Trees in Sunlight, Parc de Saint-Cloud,* and *Gateway and Fence, Saint-Cloud*—include three views of Saint-Cloud, a bucolic setting where, according to Hilsdale's letters, the two spent time together. Although Hopper referred to Saint-Cloud once in a letter to his mother, he never mentioned going there with Hilsdale.[19] Their earliest recorded trip to Saint-Cloud was in November 1906, shortly after Hopper's arrival in France; another reference to the town appears in

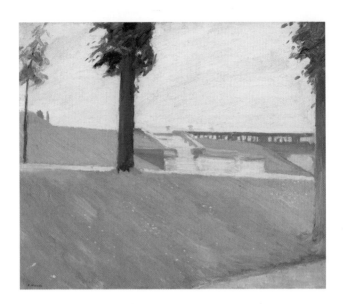

FIG. 1 *Le Parc de Saint-Cloud,* 1907
Oil on canvas, 23 3/4 x 28 15/16 in. (60.3 x 73.5 cm)
Whitney Museum of American Art, New York;
Josephine N. Hopper Bequest 70.1180

a letter of March 1909, when Hopper returned to Paris
for the second time, knowing that Hilsdale would be there
when he arrived. Although Hopper likely ventured out
to Saint-Cloud to paint on his own more than once, given
the frequency of Hilsdale's references to the town, it must
have been a meaningful place to him.

A work from 1906–9, *Couple near Poplars* (fig. 2),
painted in Paris during Hopper's first or second trip there,

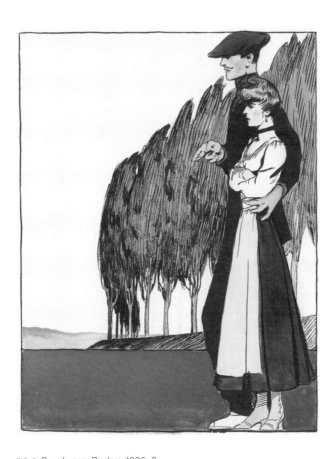

FIG. 2 *Couple near Poplars,* 1906–9
Watercolor and ink on paper, 21 3/4 x 14 3/4 in. (55.2 x 37.5 cm)
Whitney Museum of American Art, New York;
Josephine N. Hopper Bequest 70.1365

depicts a couple that might be Hopper with Hilsdale or perhaps Saies. The height of the male figure certainly suggests that this is Hopper, and the mustache might also identify the artist, who recounted that "his only concession to bohemianism [in Paris] was a thin red mustache which he shaved off because 'it looked silly.'"[20] Most noteworthy about this couple, however, is their stance: the man pulls the woman close with an affectionate gesture, while the woman stands rigid, arms folded tightly across her chest. This unresponsive or indifferent demeanor is entirely

FIG. 3 *Seawatchers*, 1952
Oil on canvas, 30 x 40 in. (76.2 x 101.6 cm)
Spring Creek Art Foundation, Inc.

in keeping with the attitude that Hilsdale, to judge by her letters, often assumed in her relationship with Hopper. The positioning of the figures in *Couple near Poplars* is also significant; while physically close, like many couples in Hopper's later paintings, such as *Seawatchers* (1952; fig. 3) and *Sunlight on Brownstones* (1956), they do not look at one another, instead gazing off into the distance. A similar position appears in another work inspired by Hopper's time in Paris, *Couple by River Bank* (1915–18), created at least five years after his return from Paris from either sketches or memory—a clear indication that his Parisian experiences resonated long after he had returned to the United States. The figure types that emerged were perhaps expressive of Hopper's feelings about Alta and their relationship and would appear in Hopper's later oil paintings. Another seemingly tense moment between a man and a woman can be found in *A Theater Entrance* (fig. 4) from 1906–10— a time when Hopper was inviting Hilsdale to the theater. A comparable exchange between a man and a woman appeared forty years later in works such as *Summer Evening* (1947; fig. 5) and *Conference at Night* (1949).

Shortly after returning to New York in August of 1909, following what seems to have been the most contentious time between Hilsdale and Hopper (a period when the most letters were written—nineteen during four months, with at least eight sent in the weeks before he sailed home), the artist painted *Summer Interior* (fig. 6), a large oil of a partially clad young woman slumped on the

FIG. 4 *A Theater Entrance,* 1906–10
Watercolor and ink on paper, 19 11/16 x 14 3/4 in. (50 x 37.5 cm)
Whitney Museum of American Art, New York;
Josephine N. Hopper Bequest 70.1378

floor of his childhood bedroom, where he slept when he
returned from Paris. In a letter dated June 16, 1909, she
wrote: "I do wish you wouldn't take everything so alarm-
ingly seriously. It is most distressing. Certainly I might
have spared you one evening this week. . . . I have not

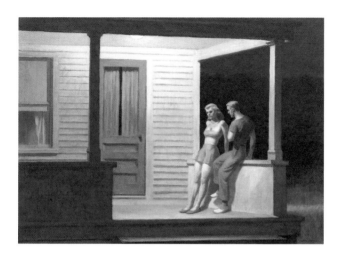

FIG. 5 *Summer Evening*, 1947
Oil on canvas, 30 x 42 in. (76.2 x 106.7 cm)
Private collection

discriminated against you—but I have not discriminated in your favor either. . . . I don't think you at all reasonable— <u>are</u> you, now?"[21] Another letter dating from 1909 clearly expressed her anger or impatience with him after he must have complained about her dismissive attitude: "I cannot see why you should take it as an affront that I would not see you Saturday evening—you had just been here Thursday evening and I expected to see you again in a few days."[22] Hopper may have felt further insulted or hurt when she changed plans with him shortly thereafter in order to spend time with some more desirable companions.

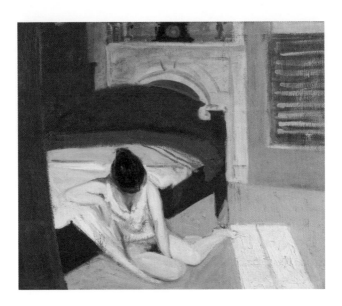

FIG. 6 *Summer Interior,* 1909
Oil on canvas, 24 1/4 x 29 3/16 in. (61.6 x 74.1 cm)
Whitney Museum of American Art, New York;
Josephine N. Hopper Bequest 70.1197

In *Summer Interior,* emotional intensity is conveyed through
the use of compressed interior space, and the presence of the
dark footboard that arches over the figure, emphasizing
the burdens of this seemingly despondent and perhaps
shamed young woman. Given Hopper's emotional distress
at the time, the figure could reflect his own feelings
of dejection.[23]

Another indication of the impact that Hopper's

experiences with Hilsdale had on him can be found in the number of works with French subjects that he continued to produce after he had returned home. Like *Summer Interior, Valley of the Seine* was painted in New York in 1909, shortly after his departure from Paris and Hilsdale. The work depicts a place Hopper frequently visited with her, and he painted it from memory, as his record book describes: "Valley of the Seine (memory) Seine from St. Germaine (painted in America between Paris trips)."[24] In Hilsdale's three letters referencing plans to travel to Saint-Germain, she wrote, "I shall be glad to go out to St. Germain with you,"[25] so it was clearly a place she and Hopper enjoyed traveling to together. The organization of the composition in *Valley of the Seine*, with its high vantage point and distant horizon line, with a river winding toward it, evokes the Saint-Germain setting—a location that would appear in the later work *Les Deux Pigeons* (fig. 7), an etching dating from 1920. This image of uncharacteristically passionate abandon could reference an experience Hopper might have had, or more likely wished he could have had, with Hilsdale when they visited Saint-Germain together eleven years earlier. The setting for *Les Deux Pigeons* alludes to Hopper's time with Hilsdale, perhaps indicating his frustration that the sexual fulfillment depicted in the print had eluded him.

Shortly after Hopper was "stricken" by the news of Hilsdale's sudden marriage in 1914, he created his largest canvas and last major oil based on a French theme, *Soir Bleu*

FIG. 7 *Les Deux Pigeons*, 1920
Etching, plate: 8 1/2 x 9 7/8 in. (21.6 x 25.1 cm);
sheet: 12 3/8 x 13 11/16 in. (31.4 x 34.8 cm)
Philadelphia Museum of Art;
purchased with the Thomas Skelton Harrison Fund, 1962

(fig. 8). Unlike the romantic fantasy that he would later create in *Les Deux Pigeons, Soir Bleu* can be seen as capturing the immediacy of Hopper's bitter despondency, with a garish prostitute whose procurer sits nearby as she seeks out clients. Given that it was painted in the fall of 1914, and Hilsdale's last letter to Hopper (signed with her new

married name) dates from October 14 of that year, it is difficult not to see the autobiographical context of *Soir Bleu*—surely the source of the hardened emotions found in *Soir Bleu* must be Hopper's own.

Hopper's relationship with Hilsdale and the insights her letters provide advance our understanding of the artist's early life and work and correct misconceptions that his life, especially his time in Paris, was as solitary as Hopper led people to believe. In pose, gesture, demeanor, and composition numerous works from the "Alta years" prefigure major oils as Hopper plumbed the emotions his pursuit of her engendered. The artist's decade-long relationship with Hilsdale now informs and helps to contextualize

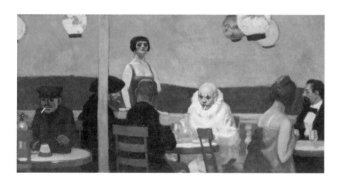

FIG. 8 *Soir Bleu*, 1914
Oil on canvas, 36 x 72 in. (91.4 x 182.9 cm)
Whitney Museum of American Art, New York;
Josephine N. Hopper Bequest 70.1208

the art he created during this period—works that are direct precursors to the masterworks that followed as he continued to "[attempt] to force this unwilling medium of paint on canvas into a record of . . . emotions."[26]

1. Edward Hopper, "Notes on Painting," *Edward Hopper: Retrospective Exhibition*, exh. cat. (New York: Museum of Modern Art, 1933), 17.

2. Guy Pène du Bois, "The American Paintings of Edward Hopper," *Creative Art* 8, no. 3 (March 1931): 191.

3. The letters are in the collection of the Arthayer R. Sanborn Hopper Collection Trust.

4. Hopper freely disclosed these two early relationships. In a December 29, 1906, letter to his mother he described a Christmas party that he had attended with Saies. Hopper's letters from Saies, owned by the Arthayer R. Sanborn Hopper Collection Trust, are cited in Gail Levin, *Edward Hopper: The Art and the Artist* (New York: W. W. Norton/Whitney Museum of American Art, 1980). Hopper's relationship with Saies is discussed in Gail Levin, *Edward Hopper: An Intimate Biography* (New York: Rizzoli, 2007), 68–70. It is clear from a December 28, 1906, letter from Hilsdale (see page 31 in this volume), responding to Hopper's invitation to attend the opera, that he was pursuing Hilsdale while also spending time with Saies, who he declared he wanted to marry six months later. Regarding Hopper's willing disclosure of his relationship with Cheruy, he inscribed several etchings, dating from 1915 to 1918, with her name. Moreover, her name was published in Hopper's lifetime in Carl Zigrosser, "The Etchings of Edward Hopper," in *Prints* (New York: Holt, Rinehart and Winston, 1962).

Under "Early Prints, 1915–1918" Zigrosser listed number 47 as "Portrait of Jeanne Cheruy." It is not known precisely when Hopper's relationship with Cheruy began, because he did not always accurately date his etchings, but it may have been within months of the abrupt October 1914 demise of his relationship with Hilsdale. Hopper's relationship with Cheruy presumably continued at least through Christmas of 1922, when she inscribed a book of romantic French poetry by Paul Verlaine to him; the romance probably did not last much longer, as he began courting Josephine Nivison in Gloucester, Massachusetts, in the summer of 1923.

5. Information about the existence of the letters came to light during an interview the author conducted with the Reverend Arthayer Sanborn on September 30, 2006, as part of an oral history project for the Whitney Museum of American Art. Transcript and audiotapes housed in the Edward and Josephine Hopper Research Collection, Frances Mulhall Achilles Library, Whitney Museum of American Art, New York.

6. As recently as 1993, when the Whitney Museum of American Art mounted the exhibition *Hopper in Paris*, curator Richard Brettell unknowingly perpetuated the myth of Hopper's solitary months in Paris when he wrote: "Hopper's entire aesthetic of urban alienation and isolation as well as his virtual obsession with architecture might very well have stemmed from the time when he lived essentially alone in the great French capital. . . . Hopper's time in Paris must have been typical of that of many foreigners who live alone and wander on their own." Brettell, *Hopper in Paris*, exh. brochure (New York: Whitney Museum of American Art, 1993), 3. And as noted, this notion of his isolation in Paris was also shared with his closest lifelong friend, Guy Pène du Bois, who was clearly unaware of his friend's romantic pursuits and his decade-long relationship with Hilsdale. Twenty-five years later, in 1956, in a series of interviews conducted over a period of several days by William Johnson, for a cover story on Hopper

for *Time* magazine, Hopper reiterated the myth of his reclusive
life in France. Based on Hopper's recounting, Johnson wrote:
"Hopper in Paris bore no resemblance to the usual American
artist in France . . . he kept to himself, sketching and painting
along the Seine and in the parks and knew almost no one . . .
he kept to himself and painted hard." Johnson, interview with
Edward and Josephine Hopper, October 30, 1956, 6. Jo had also
accepted this fable of Hopper's solitude, evident in her statement
that "he was just a lonely boy painting a blonde Paris. . . . Imagine
the loneliness of it—no one to share all that beauty with." Ibid.
Lloyd Goodrich, the former director of the Whitney Museum
of American Art, who knew Hopper well, related a comparable
fallacy when he described Hopper's life in Paris: "Living quietly,
he avoided Bohemia, read French literature, and instead of
entering an art school, painted on his own." Goodrich, *Edward
Hopper* (New York: Harry N. Abrams, 1971), 19.

7. Census record, accessed December 5, 2012, http://people.
mnhs.org/census/Results.cfm.

8. "W. O. P. Hilsdale, Successful Business Man, Passed Away,"
Sauk Centre (MN) Herald, March 26, 1942. The fact that the
announcement of Alta's father's passing appeared as a front-page
headline beneath the masthead of the newspaper, rather than
being relegated to the obituary pages, is a measure of his stature
in the community.

9. See pages 25, 26, 72, 74, and 75 in this volume.

10. He first showed at the Harmonie Club in New York with George
Bellows, Guy Pène du Bois, and Rockwell Kent, among others, in
1908. In 1910 his work was included in the *Exhibition of Independent
Artists* organized by John Sloan, Robert Henri, and Arthur B.
Davies, and in 1912 he showed with Bellows and Pène du Bois
again at the MacDowell Club of New York.

11. See page 75 in this volume.

12. *New York Evening Post*, February 24, 1912.

13. "The Season's First Special Show," *Arts and Decoration* 5 (November
1914): 29.

14. Many of the watercolors that sold from the exhibition at the Frank K. M. Rehn Gallery had been completed in Gloucester in 1923, with Hopper's future wife, Jo Nivison, an exhibiting artist and gifted watercolor painter, at his side. After Hopper began to court her, she recommended that his work be included in an exhibition at the Brooklyn Museum, where she had been invited to show. The museum bought one of his watercolors, the first painting he had sold in a decade, and the Rehn exhibition followed; the Rehn Gallery subsequently represented Hopper for the rest of his life.

15. See page 26 in this volume.

16. See page 40 in this volume.

17. See page 95 in this volume.

18. Saies's daughter's account of Hopper's profession of love for her mother, after she was betrothed to another, appears in Levin, *Edward Hopper: An Intimate Biography*, 70. Hopper had followed Saies home to England and may have left sooner than planned after an incident wherein Saies and Hopper "sat together in her family's garden while she embroidered a waistcoat for her French suitor and intended husband. Edward was helping her by biting off the threads . . . when he suddenly recoiled and said he wasn't 'going to do that for another man.' He let her know that he loved her and wanted to marry her, as she told her daughter. . . . Nothing came of it." On July 18, 1907, he left London "nine days earlier than originally planned." Regarding the painful end of Hopper's relationship with Alta, she too announced plans to marry in her letter of September 18, 1914, and Hopper was "stricken" by the news; her final letter, dated October 14, 1914, and signed with her married name, is filled with sorrow and remorse, as she begs forgiveness for causing him "unhappiness."

19. "I am painting out-of-doors all the time now, often taking the boat to St. Cloud." Edward Hopper to his mother, May 26, 1907. All the letters Hopper sent home from Paris are owned by the Arthayer R. Sanborn Hopper Collection Trust. Copies of the

letters that were transcribed by Rev. Sanborn are in the Edward and Josephine Hopper Research Collection.

20. Johnson, interview with Edward and Josephine Hopper, October 30, 1956, 6. Edward Hopper, in a letter from Paris to his mother, April 27, 1907, reported that he "had moustache for two weeks; cut it off."

21. See page 54 in this volume.

22. See page 50 in this volume.

23. Hopper scholar Avis Berman, author of *Edward Hopper's New York* (San Francisco: Pomegranate Books, 2005), concurs with this reading. She recently wrote that "the letters reveal a long-time romantic and sometimes contentious relationship . . . the vulnerable female figure depicted in *Summer Interior* may be a reflection of Hopper's own bruised feelings." Berman, *Edward Hopper, Prelude: The Nyack Years* (Nyack, N.Y.: Edward Hopper House Art Center, 2011), 13.

24. See page 50 of Edward Hopper, *Artist's Ledger—Book III*, 1924–67. Ink, graphite, and colored pencil on paper, 12 3/16 x 7 5/8 x 1/2 in. (19.1 x 11.9 x 1.9 cm). Whitney Museum of American Art, New York; gift of Lloyd Goodrich 96.21a.

25. See pages 56–58 in this volume.

26. "Notes on Painting," in Goodrich, *Hopper*, 17.

ALTA HILSDALE LETTERS

Monday evening -

Oh, I know I'm terrible about answering letters - I'm always promising to write to people and then being abused for not doing it -

I've been having the time of my life learning to run the new automobile

JUNE–JULY 1904
FROM MINNESOTA TO NYACK, N.Y.

Postmarked: June 24, 1904
From Sauk Center, Minn., to Nyack, N.Y.

<u>Monday evening</u>—

Oh, I know I'm terrible about answering letters— I'm
always promising to write to people and then being
abused for not doing it.

I've been having the time of my life learning to run
the new automobile which my father has just acquired—
It's a big red devil, and goes like the wind, and— I
haven't done any sketching— But then, it's such fun to
go whisking over the prairie— By the way, we were almost
caught in a <u>tornado</u>, last night—that is, it was almost a
tornado, if I must be truthful— But I will not give you
the list of our mishaps, as you might not find it intensely
interesting—it's only everybody's story— The town itself
is most discouraging but then—what's the use? When
I find someone to play tennis with me I'll probably feel
better— Do I sound very frivolous? I fear I am in that
mood just now, and am not at all interesting, so that's all—

Alta Hilsdale

You are a most astonishingly impatient person— Evidently you are accustomed to having your letters answered on the minute, and I never answer in less than two months, so that a summer's correspondence with me generally consists of three letters,— two from the other person and one from me—

Just now I am roasted to a cinder, burned to a crisp, etc, etc. It's been so hot here this past week— I moved about a ton of hay out of the hay loft so as to use the place for a studio, and since then it's been taking your life in your hands to go up there on account of the heat— I have a suspicion that that's a rather peculiar sentence, but never mind—

Don't you think I write a nice hand—? You see I'm getting so strong in my arms from rowing that I can't manage a small, light implement like a pen— Anyway I can't think of anything which would be likely to interest you—presumably you crave glowing descriptions of sunrises and sunsets, trees against the purple sky, etc. I don't know anything about the sunrises, and as for sunsets and trees, I have not seen a bit of scenery since I came home— You see, I haven't been any place except in the auto, and there one only keeps their eyes glued to the road, and has alternate periods of nervous

frustration when one sees a hole ahead, and the most
soul-satisfying peace when there is a little stretch of
decent road— Oh, I know that I am a most unsatisfactory
correspondent for an artist to attempt—

That's all—
Alta Hilsdale
Tuesday

Postmarked: November 20, 1906
From 21, rue Jacob to 48, rue de Lille, Paris

21 rue Jacob

My dear Mr. Hopper—

I should enjoy it very much to go to Saint Cloud, but
I really don't see when I could do it, as I have two hours
and sometimes three of French every afternoon— I
am sometimes free after tea but that is too late for any
excursions— Also I am going to see people about teachers
and going to the dentist and all sorts of things until
I am simply desperate. I hope in a week or so to have
my hours arranged so that I will know what time I have
free—but even my sight seeing now is done with a
French governess. Am I not industrious?

I am very sorry, but you see how impossible it is
just now—

Very sincerely—
Alta Hilsdale
Tuesday, Nov. 20

21 rue Jacob.

My dear Mr. Hopper.

I should
enjoy it very much to
go to Saint Cloud, but
I really don't see when
I could do it, as I have
two hours and some-
times three of French
every afternoon - I am
sometimes free after tea
but that is too late for
any excursions - Also
I am going to see people
about teachers and going
to the dentist and all
sorts of things until I
am simply desperate.

21 rue Jacob

My dear Mr. Hopper—

I can't see you Friday evening, as I am going to listen to a
talk on William Morris, and Saturday is also impossible—
Can you come right after dejeuner Sunday afternoon? If
I receive no reply I shall expect you at about two o'clock—

Cordially yours—
Alta Hilsdale
Thursday

Dec. 28 1906

My dear Mr. Hopper—

I am sorry not to have answered your letter before, but I've
been very busy and also didn't know just what evening I
could go to the opera with you. I should like very much to
go to hear Breval sing in Ariane, but I don't know just what
night it is given— Monday, I believe, but that is not a good
night for me—but I think it will be put on again during
the week and I would be very glad to go, if you care about
it too—

> Very sincerely,
> Alta Hilsdale
> 21 rue Jacob

21 rue Jacob.

My dear Mr. Hopper.
 I am
sure you deserve an
apology for having re-
ceived no answer to
your invitation for
so long a time - It
was pure negligence on
my part and I am
very sorry - but I knew
I couldn't go to the the-
atre during these past
two weeks and so I
kept putting off an-
swering - I am in the
midst of some trouble-
some changes which
may also involve mov-

21 rue Jacob

My dear Mr. Hopper,

I am sure you deserve an apology for having received no answer to your invitation for so long a time— It was pure negligence on my part and I am very sorry—but I knew I couldn't go to the theatre during these past two weeks and so I kept putting off answering. I am in the midst of some troublesome changes which may also involve moving. I don't know just what I am going to do, and I can't make any engagements for another week anyway. But I assure you that I appreciated your invitation very much, even if I have been beastly about answering.

> Very sincerely,
> Alta Hilsdale
> Wednesday

My dear Mr. Hopper,

I am sure you are very kind—and I am very slow about
answering, but I am really very busy,—you needn't laugh
at it, I really am— I should like very much to see either
Mignon, or Manon at the Opera Comique—but not this
week—next week—if it please you—

Thank you very much—

> Sincerely,
> Alta Hilsdale
> Sunday, Feb 17

Please don't count the "verys" in this letter—they were
very accidental—

Postmarked: May 19, 1907
From 21, rue Jacob to 48, rue de Lille, Paris

My dear Mr. Hopper—

Yes, I should like very much to go out to dinner tonight.
I shall expect you at about seven—

Sincerely—
Alta Hilsdale

21 rue Jacob

My dear Mr. Hopper—

I think I shall have to put off the Café d'Harcourt for
this week— I cannot go tomorrow, and think I'd better
not try to this week, as I have several other things just
now— Thank you very much —

> Cordially yours —
> Alta Hilsdale
> Monday evening—

21 rue Jacob

My dear Mr. Hopper,

I am so sorry I did not succeed in getting a note off to you yesterday as I should have done. I cannot go out to dinner with you tonight, but will be glad to go Thursday evening if you wish.

> Sincerely,
> R.A. Hilsdale
> Monday

21 rue Jacob

My dear Mr. Hopper,

I am surprised to hear where you have been wandering—
I hope to wander off myself soon for a breath of air,
and have been intending to write and ask you to come and
see me before I go— If you come over Friday evening
we will go out to dinner together, as I am patronizing the
restaurants rather than the pension at present—

Cordially yours,
Alta Hilsdale

 21 rue Jacob

My dear Mr. Hopper,

I am very sorry but I have another engagement for Sunday
evening— Thank you very much anyway— I should have
let you know sooner but I am so lazy about such things—

 Cordially yours —
 Alta Hilsdale

Postmarked: 1908
From Sauk Center, Minn., to 244 West 14th Street, New York

Dear Mr. Hopper—

I have recklessly stated now several times "I am going back to Paris"—and really I am terrified for fear the Fates will take offense at my confidence and prevent it— But I have great hopes of sailing about the last week in January, and I am going to try to have some little time in New York—

Do you know, I had a very alarming dream about you a while ago—you tried to throw me down a cliff or something, and I had an awful time trying to save my life— I decided you must be hating me very hard to cause such a dream and wondered if it is because I have never answered your note asking me when I was going to be in New York again— But I really didn't know, until very recently— I shall let you know when I arrive and will be very glad to see you—

Skilly Hilsdale

Dear Mr. Hopper ——

recklessly stated I have
several times "now I
am going back to
Paris " —— and
really I am ter-
rified for fear
the Fates will
take offense at
my confidence
and prevent it ——
But I have great

No postmark or stamp
From Brevoort Hotel, 20 West 8th Street, to 244 West 14th Street, New York

My dear Mr. Hopper,

Can you not come and see me this afternoon? I shall be in at about five o'clock and would be so glad to see you—

> Very sincerely,
> Skilly Hilsdale
> 20 West 8th st

14 rue de l'Abbaye
Paris

My dear Mr. Hopper,

I have just been back in Paris a week, and found your letter
at the American Express. You are in luck to be coming back
this spring, and especially to be going to Spain. I am still in
the St. Germain quarter, altho' not in the same house but
I do not think I shall stay here and really do not know where
I shall go then. However I am always easy to find thru the
American Express and I shall be very glad to see you when
you come to Paris.

Sincerely yours
Alta Hilsdale

14 rue de l'Abbaye
Paris

My dear Mr. Hopper,
 I have
just been back in
Paris a week, and
found your letter
at the American
Express. You are
in luck to be
coming back this
spring, and
especially to be
going to Spain.

Postmark illegible (March 1909?)
From 218, boulevard Raspail to 48, rue de Lille, Paris

218 boul. Raspail

My dear Mr. Hopper—

Now why couldn't you tell me you were going to be here
this winter, when I saw you in New York? Just natural
secretiveness? I think it was shabby of you— Come
Saturday evening, if you can— I shall be very glad to
see you—

Cordially,
Alta Hilsdale

218 boul. Raspail

My dear Mr. Hopper—

I am so sorry to have missed you Saturday evening— I was here all the time, but the old dame had not heard me come in from dinner, and did not bother to find out— I hoped you would come back— I saw a tall man wandering up and down outside and [thought] that it was you, and that you were waiting to see me come in from dinner—so I went down, but it was not you, and I took a little turn to see if I would meet you, but only got spoken to by a Frenchman for my pains— It's too bad— Will you come again Monday?

Sincerely yours,
Alta Hilsdale

Postmarked: March 1909
From Paris (no return address) to 48, rue de Lille, Paris

My dear Mr. Hopper—

It is too cold today for it to be pleasant to go to Saint
Cloud, so I have accepted another invitation for this evening
and we will go next week instead. I find that Wednesday is
impossible after all, so will say Thursday, if that suits you,
and I will expect you at about five, provided it is a decent
day of course.

> Sincerely yours,
> RAH

Postmarked: April 16 or 18, 1909
From Paris (no return address) to 48, rue de Lille, Paris

My dear Mr. Hopper,

I am sorry I shall not be in Saturday evening—will you come Tuesday instead? I think the Concert Rouge have [*sic*] an interesting program that evening, to which we might go, if you wish.

Cordially,
RAH

218 boul. Raspail

My dear Mr. Hopper,

Notwithstanding that your note was dated Thursday, I did
not receive it until this morning, so I could not have let
you know to come even if I had not had an engagement for
this afternoon— As it happens, I went to the Independants
[*sic*] last week, and I must say I shouldn't be equal to it
again for some time— Frankly, I was bored to death—

When are you going to bring your friend Miss De
Kerstrat to see me? I am sorry I have just been to the
exhibition, and thank you very much for asking me—

> Very sincerely,
> Alta Hilsdale
> Sunday—

218 boul. Raspail

My dear Mr. Hopper,

I cannot see why you should take it as an affront that I
would not see you Saturday evening—you had just been
here Thursday evening and I expected to see you again in
a few days, while the friend with whom I dined last night
I had not seen for three weeks— I think it was a very
ordinary thing to do— However I am very sorry you were
so bored, and also that I cannot possibly see you until
Thursday— I shall expect you then, unless I hear from
you to the contrary.

Sincerely yours,
Alta Hilsdale
Sunday

218 boul. Raspail

My dear Mr. Hopper—

You are certainly right about Sunday being an impossible
day to go anywhere— I think I told you that I could not
go this week, and the first part of next week I shall not be
able to get off in the afternoon in order to start at about
four o'clock, as I think we should— How would Thursday
suit you? Of course finally it will have to depend upon
the weather—

Sincerely yours,
Alta Hilsdale

21 rue Jacob

My dear Mr. Hopper,

How very slangy [?] you are! I shall be very glad to dine
with you Sunday evening. I hope it will not be such windy
weather, so that we can sit outside someplace. I am quite
frozen today.

> Cordially,
> Alta Hilsdale
> Friday

2I rue Jacob

My dear Mr. Hopper,

Thank you very much for your invitation but I cannot
possibly dine with you this week— I am sorry to say that
I cannot give very much time to my friends just now, as I
want to get as much done as I can this month and next.
The time goes so alarmingly fast and I seem to accomplish
nothing. Thanking you again, I am

> Yours sincerely,
> R.A. Hilsdale

21 rue Jacob

My dear friend,

I do wish you wouldn't take everything so alarmingly
seriously. It is most distressing. Certainly I might have spared
you one evening this week— I might also have spared several
other people one evening—and where would my evenings
have been? I have not discriminated against you—but I have
not discriminated in your favor either— Surely if I chose
not to go out for a week or so, I ought to treat everyone
alike—don't you think so? I am sorry you take it in such
a different way—but I must say I don't think you at all
reasonable—<u>are</u> you, now?

> Sincerely,
> R.A. Hilsdale
> June 16

21 rue Jacob

My dear Mr. Hopper,

I am going out Monday evening, but shall be glad to see
you Thursday or Friday if you can come then.

Sincerely,
Alta Hilsdale

21 rue Jacob

My dear Mr. Hopper,

I shall be glad to go out to St. Germain with you Wednesday if you wish. I hope we shall have a few clear days now.

Sincerely,
R.A. Hilsdale
Sunday

21 rue Jacob

My dear Mr. Hopper,

The weather is certainly not propitious, but if it is nice
Saturday evening I shall be glad to go out to St. Germain
with you then.

> Sincerely,
> R.A. Hilsdale
> Wednesday

Postmarked: July 20, 1909
From unknown location (no return address) to 48, rue de Lille, Paris

My dear Mr. Hopper,

I hope you won't be too startled by this envelope— I
cannot find another one— Shall we make another attempt
at St. Germain Thursday? I am afraid it will rain if
we say "St. Germain" out loud— However, we will dine
somewhere anyway if you wish.

> Sincerely,
> Alta Hilsdale

Postmarked: July 29, 1909
From 21, rue Jacob to 48, rue de Lille, Paris

21 rue Jacob

My dear Mr. Hopper,

Come over tomorrow, Thursday, afternoon at about half
past four and we will go out to tea someplace.

Hastily,
R.A. Hilsdale

21 rue Jacob

My dear Mr. Hopper,

I shall be very glad to see you Sunday evening—if I have
not passed away from the heat by that time—

In haste,
RAH.
Saturday

21 rue Jacob

My dear Mr. Hopper,

I am sorry to say I cannot go to Chartres this week as I am
taking some extra lessons and shall be very busy, but I thank
you very much—also for your invitation to dinner which
I am afraid I cannot accept just now either. I am not going
out at all just at present.

Sincerely yours,
R.A. Hilsdale.

21 rue Jacob

My dear Mr. Hopper,

I should have answered your note inquiring about my
health (!) before if I had not been so busy moving. I am
sorry to say that just at present I am very awkwardly placed
for seeing people—the only place I have at present to
receive them being the salon which is filled with the usual
collection of pension curiosities every evening, so that it
is most uncomfortable to try to talk to anyone. However,
I hope to have another room in a few days, where I shall
be very glad to see you.

Sincerely,
Alta Hilsdale

21 rue Jacob

My dear Mr. Hopper—

Will you think me very awful if I ask you to change from Sunday night to Monday? I have been asked to meet some people I am anxious to know Sunday evening and I do not know when I might have the opportunity again. Hoping this will not inconvenience you, I am

>Cordially yours,
>Alta Hilsdale
>Saturday

Postmark illegible (summer 1909)
From Sauk Center, Minn., to 244 West 14th Street, New York

My dear Mr. Hopper,

Your note reached me just the morning I was leaving New York, and in the excitement of getting home after such a long absence I forgot that I had not answered you— I am awfully sorry—also sorry that I left New York so soon that I couldn't have you come and see me but I hope you will come if I am in town again in the fall— I am staying over in the cottage on the lake shore just now, so that I live in a boat—and in a bathing suit! A frightfully lazy existence— not even the strenuousness of real camping—just half way between— At present the lamp I have to write by, is bringing swarms of flying beasts of all kinds— How they penetrate the screen I'm sure I don't know, but I grant them the victory and leave the field—

Hoping to see you in the fall— I am living in hopes of New York or Paris— I am

Cordially yours,
Alta Hilsdale

Postmarked: 1910
From 21, rue Jacob to Hôtel des Ecoles, 15, rue Delamber, Paris

21 rue Jacob

My dear Mr. Hopper,

I was very glad to get your letter saying that you were
in Paris again. You see that I am back at the old address
again—and I shall be very glad to see you Monday
evening if you can come then.

Cordially yours,
Alta Hilsdale
Saturday

Postmarked: June 15, 1910
From 21, rue Jacob to Hôtel de l'Elysie, 3, rue de Beaune, Paris

21 rue Jacob

My dear Mr. Hopper,

I will be very glad to see you Thursday evening at about half past eight, if you can come.

Mr. Chaffee has sailed for home already—a couple of days before I got your note. I should have answered before but I have been very busy this week.

Cordially,
Alta Hilsdale
Wednesday

Postmarked: July 10, 1910
From 21, rue Jacob to Hôtel de l'Elysie, 3, rue de Beaune, Paris

21 rue Jacob

My dear Mr. Hopper,

If it is a nice day Friday I will meet you at the Gare
Montparnasse for the 11.55 train. I have a lesson in Passy
at 10.30, but can take the Metro right to the station.
Of course if it is a bad day you will not expect me, and if
my lesson hour is changed I will have to put off the trip
until Sunday, tho' Friday would be a better day I suppose.
If you have anything else for that day just let me know.

> Cordially,
> Alta Hilsdale
> Wednesday

21 rue Jacob, Paris

My dear Mr. Hopper,

I am still in Paris and still in the same place. You see I don't roll about the way you do. I wish I could. I expect to stay until about June, and shall probably remain in the same pension. If I should move they will of course have my address here, and I shall look forward to seeing you when you come over.

This is the day before Christmas, and it is raining hard, and I am in anything but a holiday frame of mind. That may be partly induced by the fact that I have six envelopes all addressed, lying on the table before me, and I feel that I must write the letters to put in them today. You understand that, don't you?

I hope you are enjoying yourself, and have had a good winter, so far. You are lucky to be planning another trip for this spring.

Sincerely,
Alta Hilsdale

Postmarked: May 4, 1911
From 21, rue Jacob, Paris, to 53 East 59th Street, New York

21 rue Jacob, Paris

My dear Mr. Hopper,

I was sorry to hear you are not coming to Paris this spring.
It is really beautiful here just now, as we are having a real
Paris spring, for a change. At least that's what they like
to call it, perhaps because it happens so rarely. It's most
becoming to Paris, however. I took a long walk a few days
ago in the sunshine, along the banks of the little canal
away off in the Butte Chaumont direction. It was an
undiscovered country to me out there and I had a lovely
time prowling about. Yesterday I spent the day at Chantilly.
The park was lovely with the leaves just out, and we were
so tempted by the many vistas and avenues that we nearly
walked our feet off, and I came back nearly dead. The only
drawback to the day was that four Americans got into the
same compartment with us going out—and as if that

were not bad enough, they talked <u>singing</u> all the way out. I was perfectly furious. I certainly don't want to have to think about singing when I'm taking a day off. I think it's quite hopeless not to be able to enjoy a perfect day without wanting to sing about it, or paint it or write about it.

I haven't seen any exhibitions lately except the Salon des Humoristes. The National and the Independants [*sic*] are both open now but I haven't been to them yet. I am planning a trip of a few days to see Rouen, Amiens and perhaps Riems [*sic*]. I do want to see them before I leave here, which will be sometime in July I expect. I shall certainly let you know when I am in New York, as I shall probably stay there a week or so, and would be very glad to see you. I am very distressed at the idea of leaving Paris, but it cant [*sic*] be helped. Perhaps I shall discover a violent enthusiasm for America arising in me when I get back there. But Paris is such a cheerful place to be poor in. There is the luncheon bell, so I shall return to my rabbit and red ink.

Cordially yours,
R.A. Hilsdale

Postmarked: November 19, 1911
From Hotel Brevoort, 5th Avenue at 8th Street,
to 53 East 59th Street, New York

Dear Mr. Hopper,

I am in New York for a few days and would like very much
to see you if you are in town. Can you come tomorrow
evening at about half past eight? I am at 20 West 8th, you
know, and I wish you would telephone tomorrow morning
if you can, so that I may know whether to expect you.
It is 146 Spring. Hoping to see you.

> Cordially yours,
> Alta Hilsdale
> Sunday

Dear Mr. Hopper,

I assure you I am neither dead nor married, tho' I was in the
hospital when I got your letter. Also I am not clerking in a
store, tho' this paper looks it. I am just waiting around here
in Minneapolis for the doctors to tell me I may go home,
as I still have to go to them for daily treatments. I have been
having some operations on my nose and throat, but I hope
to be able to go home in a few days. I don't know whether I
shall be able to get away this fall or not. I hope so, but am not
very cheerful about it. I am certainly tired of the west (if this
can be called west any more) and if I can't have either Europe
or Japan, I would be quite pleased to get back to New York.
Are you off again to Europe soon? I get so fearfully tired
of myself when I can't move around a bit. I am almost
ready to steal my way riding in boxcars by this time. Are
you going to try to stay in New York through the summer
and suffocate? I am not very fond of New York but would
endure any heat to be there for awhile now for a change.

Can you get me Miss Knowlton's address? Mrs. George
Harting, I should say. Perhaps it's in the directory. I wish you'd
send it to me if you can find it without too much trouble.

Cordially,
R.A. Hilsdale

DONALDSONS
BALCONY WAITING ROOM
GLASS BLOCK

Minneapolis.

Dear Mr. Hoffee...

I assure you I am neither dead nor married, tho' I was in the hospital when I got your letter. Also I am not clerking in a store, tho' this paper looks it. I am just waiting around here in Minneapolis for the doctors to tell me I may go home, as I still have to go to them for daily

Sauk Center, Minn.

Dear Mr. Hopper,

I do not know whether I can assure you that I am among the living, that is open to doubt, but of myself I have none— I am dead and buried—which makes it a bit difficult for me to find anything to put in a letter. Graves are not exciting, even a "farthest north" one like this, with the snow over it, and three suns shining on it (doesn't that display sound Arctic? The sun-dogs were really so bright the other day that it looked that way) and the thermometer even more down than I am—he's burrowing and sniffling down around 35 below, I believe. As to how long it will last, I don't know— I don't mean the weather but my defunct condition. Can a condition be defunct, by the way? New York seems very far off, and I don't know when it will be any nearer. Paris I don't believe exists at all—anyway, I hope it doesn't if I can't be there. Also I think it's horrible of me to be so peevish even in a letter, and I hope you are in a more cheerful state of mind—tho' I don't remember you as radiating contentment. Are you not starting forth to wander again soon? If I ever do see New York again, I shall certainly let you know.

Cordially,
Alta Hilsdale

My dear Mr. Hopper,

Do you suppose for an instant that I am staying here from choice? The only trouble is to find the money to go somewhere else. I had so many colds last winter in this climate that my father wants me to go to California for the winter, but that idea doesn't please me at all, so at present we are at a standstill, and I don't know what I shall do. I am getting some sewing done anyway—in case of fire. I certainly wish I were in New York where there is something to see and hear. How is the world treating you? Do you get much painting done, or does your work leave you too fagged? I hope not.

Cordially,
Alta Hilsdale

My dear Mr. Hoffen,

Do you suppose for an instant that I am staying here from choice? The only trouble is to find the money to go somewhere else. I had so many colds last winter in this climate — that

Postmarked: December 1912
From Sauk Center, Minn., to 53 East 59th Street, New York

My dear Mr. Hopper,

I really am coming East now—at last. I leave here next
Sunday the 15th but I am going to stay a few days in
Minneapolis and also in Chicago, so I shall probably reach
New York just before Christmas. I have no idea yet whether
I shall make a long stay or a very short one but at any
rate I shall hope to see you shortly after Christmas. I may
possibly go out in the country for a few days, just over
Christmas. I'm afraid I haven't much enthusiasm for the
day anymore— I wish I had. I suppose the town looks
very gay in honor of it just now. I am looking forward to
seeing it again.

I hope your Christmas will be a very happy one.

With best wishes,
Alta Hilsdale

101 Waverly Place

Dear Mr. Hopper,

I am not yet at the above address but am going to get
my trunk over there today and try to get unpacked. I hoped
to be able to ask you to come tonight, but besides being
frightfully tired I have such a cold I couldn't talk to you if
you did come, so I am going to ask you to come Wednesday
evening if you can—and I hope I shall not be feeling quite
so rotten. My phone is 999 Spring. I shall expect you at
about nine o'clock on Wednesday unless I hear from you.

Sincerely,
Alta Hilsdale

Postmarked: January 24, 1913
From Hotel Brevoort, 5th Avenue at 8th Street,
to 53 East 59th Street, New York

My dear Mr. Hopper,

Please forgive me for not answering your note before. I am
so sorry I cannot dine with you this week. Will Monday
evening do? If that is not convenient for you, let me know.
Otherwise I shall expect you—

 Cordially,
 Alta Hilsdale
 Friday

Postmarked: April 8, 1913
From New York (no return address) to East 59th Street, New York

My dear Mr. Hopper,

I have just had a message to remind me of a theatre engagement I made last week for Tuesday evening, and which I had entirely forgotten when you telephoned. I am so sorry, but hope that you will get this in time so that it will not inconvenience you too much. Can you not come Friday evening? Perhaps you will telephone tomorrow around noon and let me know. I regret very much having made this mistake and having to let you know so late.

> Sincerely yours,
> Alta Hilsdale
> Tuesday

Postmarked: May 20, 1913
From New York (no return address) to 53 East 59th Street, New York

My dear Mr. Hopper,

I am so sorry you have been ill, and hope you are feeling
all right again. It did not matter at all about Saturday
because I did not come back to town until Monday, after
all. It was so nice in the country that I was easily persuaded
to stay over Sunday.

 I shall be glad to see you when you have quite
recovered from your illness, which I hope will be soon.

> Sincerely,
> R.A. Hilsdale
> Tuesday

Dear Mr. Hopper,

If you can come tomorrow, Saturday at about half past
twelve, we can go out to luncheon together. Don't bother
to let me know if you <u>can</u> come, because if I don't hear
I shall expect you—but if it will not be convenient for
you I hope you will send me word.

> Cordially,
> R.A. Hilsdale
> Friday

My dear Mr. Hopper,

I have been out here at the cottage ever since I came home. It was so very warm then that we came right out in the hopes of cooling off. Since then we have had samples of all kinds of weather. I had an unpleasant surprise when I reached Minneapolis, as I found my mother there in the hospital. I stayed a week until she was able to come home. She is feeling quite well now but I have to watch her all the time to keep her from being too energetic. My present occupation is dish-washing mostly—with a little cooking and sweeping. Inspiring, isn't it?

I'm sorry you have even forgotten how money looks. So have I, but then I don't need it here. I hope you will soon have a chance to refresh your memory.

I suppose the heat has been frightful in New York. However, I think I'd endure it cheerfully to be back there.

> Sincerely,
> Alta Hilsdale

SEPTEMBER 1913–OCTOBER 1914
FROM MINNESOTA AND NEW YORK
TO NEW YORK AND MAINE

Postmarked: September 27, 1913
From Sauk Center, Minn., to 3 Washington Square North, New York

Dear Mr. Hopper,

Washington Square North sounds quite alarming—
I am sorry I can't find a decent envelope in the house,
but refuse to go out and buy paper just now—even for
Washington Square North. I am getting ready to go
away again but just how soon or where I don't yet know.
Of course I shall let you know when I come to New
York. I am getting very restless here. I stand it about
so long and then get rather desperate.

I hope you are having good luck, and like your
new studio.

Cordially,
Alta Hilsdale

Postmarked: December 1, 1913
From 38 Washington Square West to 3 Washington Square North, New York

Dear Mr. Hopper,

If you have nothing to do Tuesday evening I should be
very glad to see you. I am now at 38 Washington Sq.
West. Will you let me know? The telephone is Spring
4881 and I shall be in about all morning I think.

> Cordially,
> Alta Hilsdale

My dear Mr. Hopper,

I find I shall have to go out tomorrow morning at ten,
so could you let me know before that? If they tell you
I don't live in the house, don't believe them. They are
mostly Italians and not at all accustomed to my name yet.

<div align="right">

Alta Hilsdale
38 Wash. Sq. W.

</div>

Postmark illegible (post-1913)
From Sauk Center, Minn., to 3 Washington Square North, New York

My dear Mr. Hopper,

Thank you so much for the book. I was anxious to read it and I am sure I shall enjoy it, tho' I have only found time to read a few pages so far. I wonder why it is that translations always sound so naïve. Have you noticed it?

I have not started any dancing classes yet because my father objects—for some absurd reason. But I have been learning to run a motor car, as Father bought one just before I came home. It is great fun, but I wish I could understand the insides of it too, as now if anything goes wrong I am quite helpless. Also I am quite expecting to smash myself into bits before the summer is over.

We are having very hot weather here, and I hope if New York is having such heat too that you will soon be going up to Maine. I hope you will have a good summer.

> Cordially,
> Alta Hilsdale

My dear Mr. Hopper,

I think you must have missed one of my letters this summer, as you say you have only had one, and I wrote quite a long while ago to thank you for the book of Arnold Bennet's which you sent me. If you didn't get it I must thank you again. I enjoyed it very much—it was, as you said, not very weighty, but then I am feeling like the tired business man just at present anyway. We have a war of our own on our hands, and are trying to save our trees from the caterpillars. I have been wallowing in tar the last couple of days. Then I have painted part of the house (—I do house painting rather well) and I have to get up at six every morning to bring Father in to town! He will not learn to run the car— but I am determined to teach Mother to drive it. I have had no real accident yet, and enjoy running it very much.

I hope you are having a good time up there by the sea. I have no recollections of Miss Lockett, but I suppose I should remember her if [I] should see her.

We have been having frightfully hot weather— I certainly envy you for being at the sea-shore.

Wouldn't you like to see some of the patriotic excitement in Paris at present?

Sincerely,
Alta Hilsdale

Dear Mr. Hopper,

I suppose I shall have to begin to tell some of my friends
that I am to be married soon to Mr. Bleecker. It has not
been decided very long and I find it very hard to believe
myself. I have told no one here yet.

 We are to live in Brooklyn for the present, at 42 Sidney
Place, and if you should care to come over I would be
very glad indeed to see you.

<div align="right">
Always your friend,

Alta Hilsdale
</div>

Dear Mr. Hoffen,

I suppose I shall have to begin to tell some of my friends that I am to be married soon to Mr. Bleeker. It has not been decided very long and I find it very hard to beleive myself. I have

42 Sidney Place
Brooklyn

My dear Mr. Hopper,

I cannot tell you how sorry I am to have made you unhappy. Surely you must know how deeply I regret it.

I want to tell you why I sent those telegrams—to your house as well as your studio—in case it should have caused you any annoyance. I was in the next town at the time, and your messages were telephoned to me from home, so perhaps I did not get them quite clear. I was afraid you were starting at once and did not know where to catch you to prevent the useless journey. I wanted to explain, in case you thought it inconsiderate of me, and to tell you that I would have done anything I could not to distress you any more.

I thank you with all my heart for all you have done for me and offered me, and beg you to forgive me for causing you unhappiness.

Most sincerely,
Alta Hilsdale Bleecker

studio — in case it
should have caused you
any annoyance. I
was in the next town
at the time, and your
messages were telephoned
to me from home, so
perhaps I did not get
them quite clear. I
was afraid you were
starting at once and
did not know where
to catch you to prevent

42 Sidney Place,
Brooklyn.

My dear Mr. Hopper,

I cannot
tell you how sorry I am
to have made you
unhappy. Surely you
must know how deeply
I regret it.

I want to tell you
why I sent those
telegrams — to your
house as well as your

You are the type of a man who does not believe a girl can be platonic indefinitely It seems that you are in a class who regards every girl as one with designs to besiege your affections

You are the type of a
man who does not
believe a girl can be
jealous. ~~indefinitely~~
~~Have alwe~~. It seems
that you are in a class
who regards every girl
as one with designs
to besiege your affections